Emilie Donovan Photography
edonovanphotography@gmail.com
www.edonovanphotography.ca

Bees
by

Emilie Donovan

Memories

My grandpa was a beekeeper from Germany as they had been for a few generations before him. I grew up around bees and grandpa taught me what he knew. I learned what I could only having the mind of a child. The bees have a foraging area about two miles and no more than four. Grandpa kept them foraging in clover and it was the sweetest honey I tasted. Of course, I am biased because that is what I grew up on. As for canola, he said it never made good honey because it came out grainy. It saddens me that industrial bee farms are encouraging bees to forage in canola especially considering that 80% of canola in Canada is a GMO product. Recently I learned of a medical grade honey where bees forage herbal plants for optimal healing properties in the honey.

Biomimicry is the study of our environment and how nature has adapted to the challenges presented in an environment that is sustainable over the long haul. No matter how hard we try to make sustainability a priority, unless we are studying how nature does it, than it cannot work. It is within this understanding we learn from bees how to be more effective communities and to create awareness that we are part of a larger whole; we are not independent of others.

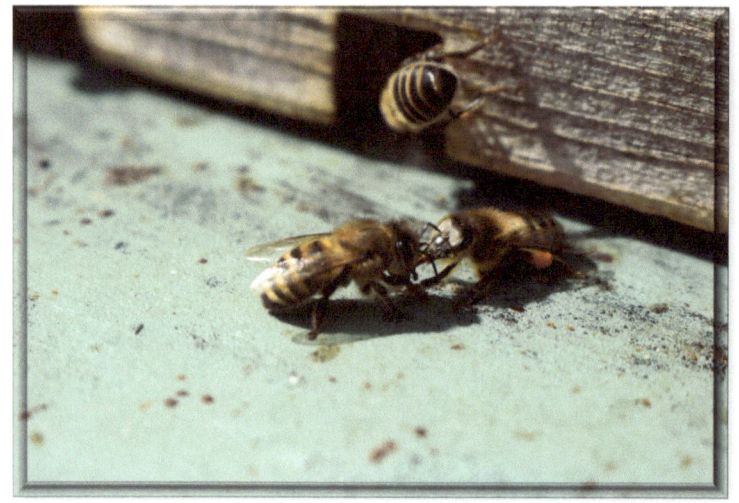

Did you know bees communicate through round dancing, waddles, and shaking to indicate direction and distance of food source?

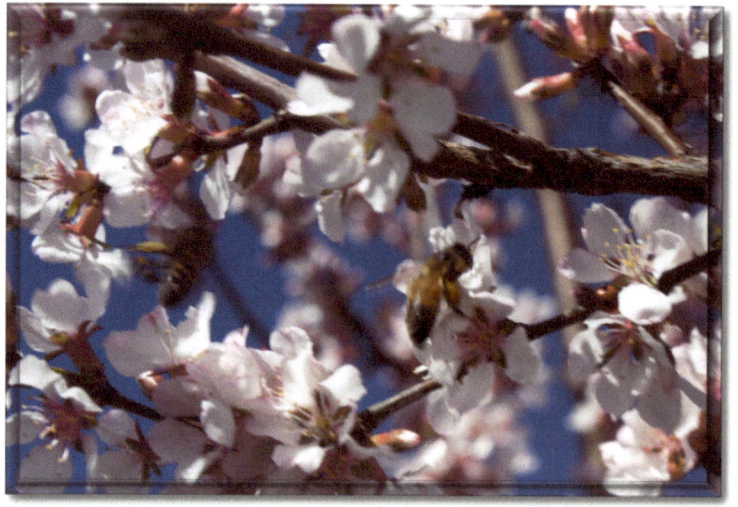

Did you know Nanking cherry
bushes have sweet blossoms
bees love to gather nectar from?

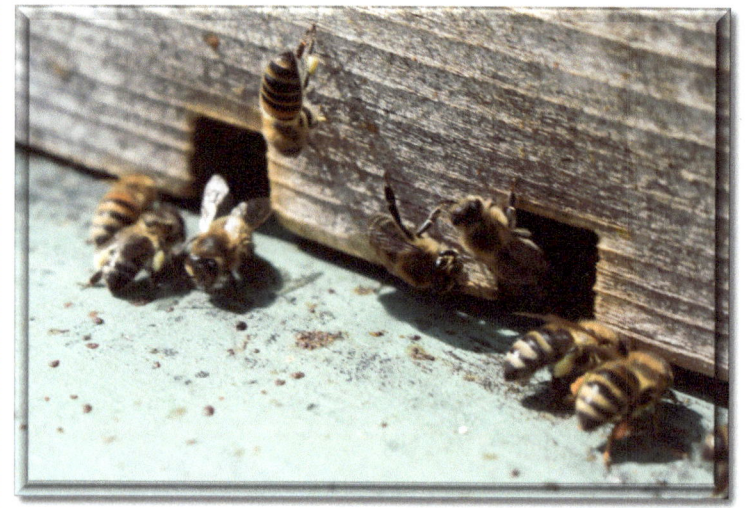

Did you know bees live in a group called a colony?

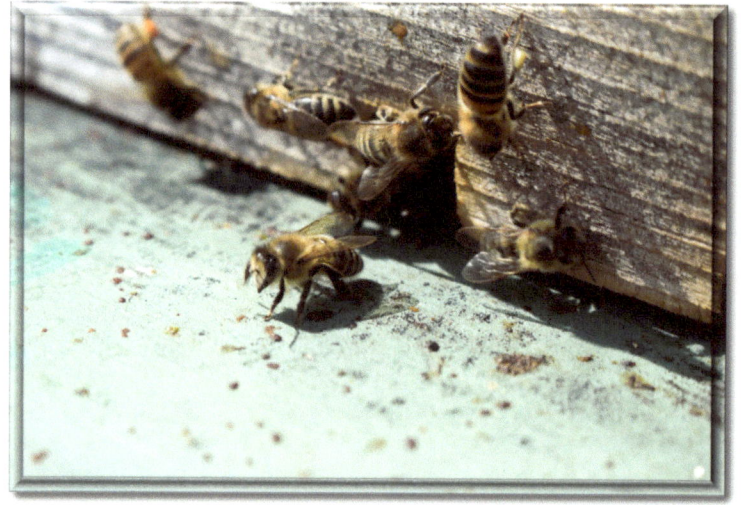

Did you know bee colonies live
in supers that are boxes with lids
stacked on each other to hang
the honeycombs on?

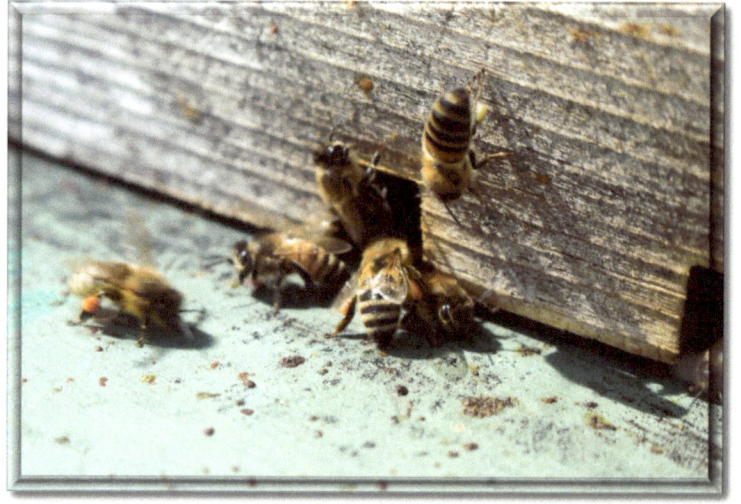

Did you know a drone is a male bee?

Donovan / Bees / 14

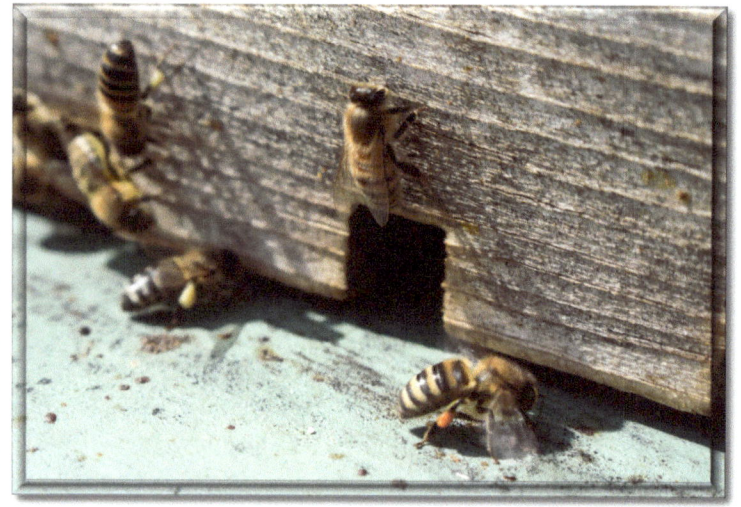

Did you know all the bees in a hive are female except 1-3 drones that fertilize the queens' eggs during summer?

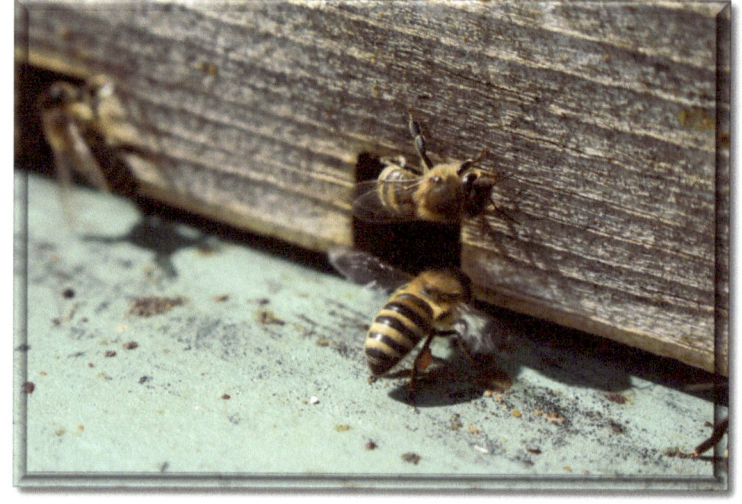

Did you know processed honey
has none of the health benefits
of real honey?

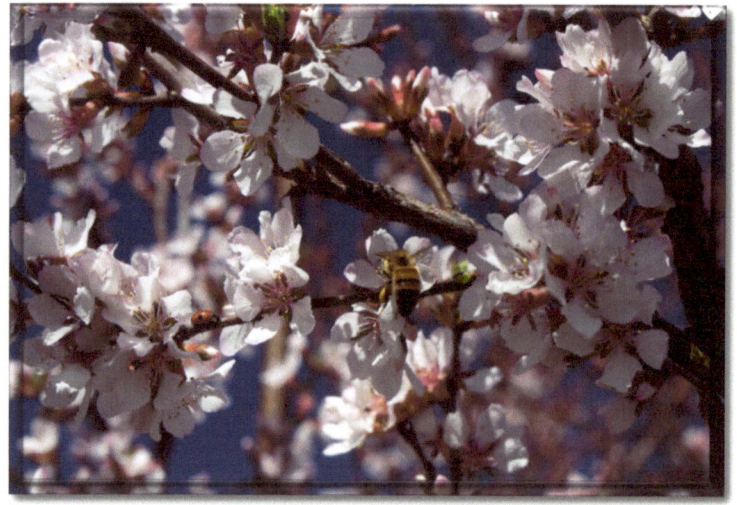

Did you know honey stores forever if water is not added to the honey?

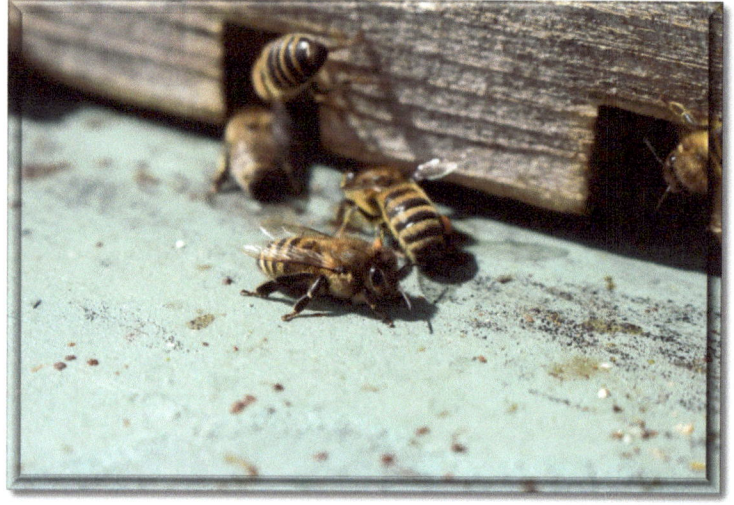

Did you know there are rival
bee colonies and guards check
each bee coming in and out to
make sure they aren't
stealing?

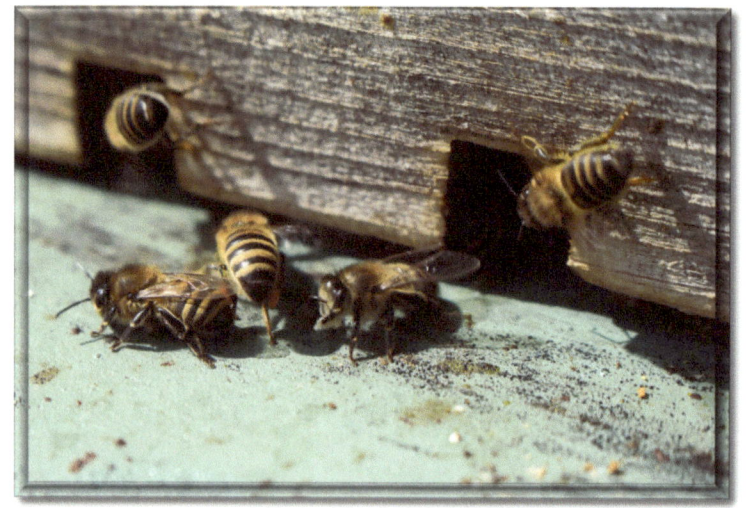

Did you know there are broodcombs for the baby eggs and honeycombs for the honey?

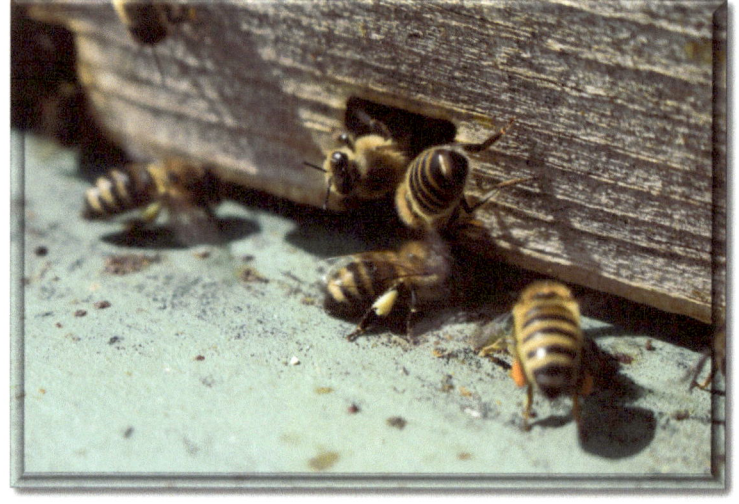

Did you know each bee has a certain job?

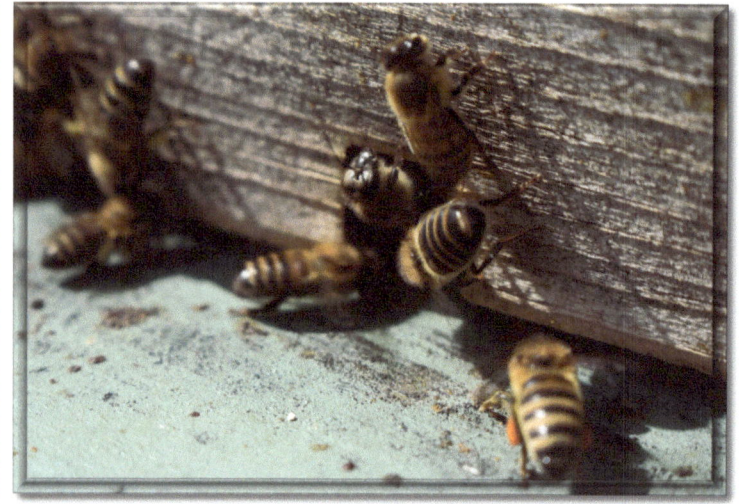

Did you know the life span of a bee depends on when they are born and their role in the colony? Healthy queen bees can live up to 4 years.

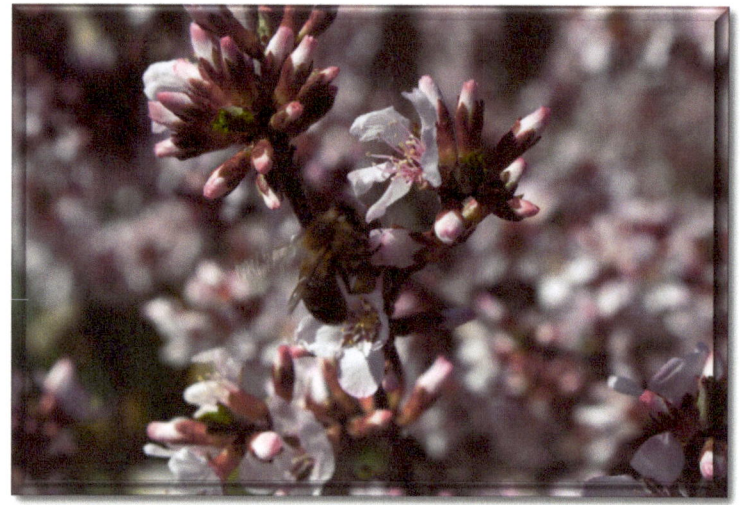

Did you know there are ten types of honeybee, not including the hybrid Africanized bee?

www.ingramcontent.com/pod-product-compliance
Lightning Source LLC
Chambersburg PA
CBHW040915180526
45159CB00010BA/3070